Between Heather
and Grass

First edition.

ISBN: 978-1-9164704-3-9 (Paperback)
ISBN: 978-1-9164704-4-6 (eBook)
ISBN: 978-1-9164704-5-3 (Kindle Edition)

Book design by: Darlene Swanson/van-garde.com

This is a work of creative non-fiction. Some parts have been fictionalised, to varying degrees, for various purposes.

For permission, email: holisticlinguist@gmail.com

Published by Holistic Linguistics, Nairn, UK.

Between Heather and Grass

*Poems and Photographs Filled with
Love, Hope and Whippets*

Poems and photographs by

Xenia Tran

CONTENTS

Dedicated to Paul, Eivor, Pearl and Jamie

BATHING IN LIGHT

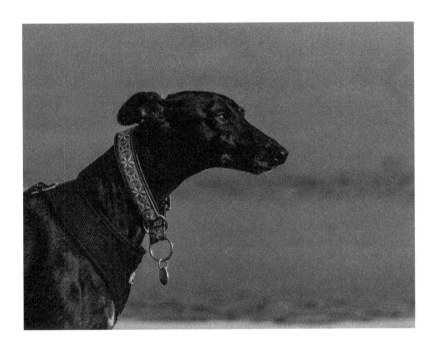

We're on our way again. On our way to new discoveries, along a trail of dreams. The sun warms the sea after a cold night. Mist rises, a haze of blue. A haze of peace over a calm sea. That's how we'd love the world to be.

floating gulls
together we find ourselves
bathing in light

Thirty per cent of net profits from the sale of this book will be shared with Children with Cancer UK, in memory of our nephew Jamie Baker. A further thirty per cent of net profits will be shared with animal rehoming charities at the end of each financial year. The charities we donate to will be announced on our blog at whippetwisdom.com and via our Twitter feed @WhippetHaiku

INTRODUCTION

Welcome to *Between Heather and Grass*, our second collection of poems and photographs that capture special moments in the Scottish Highlands with our adopted whippets Eivor and Pearl.

When we selected images and poems for our first collection *Sharing Our Horizon* (September 2018), a few poems were set aside especially for this second book. One of those was *A Message from the Stars*, a poem about our nine-year-old nephew Jamie Baker who suffered from leukaemia. His story shows us what love, football and a big dream can do, even in the most difficult circumstances.

With these poems in place, I dedicated the following year to creating photographs and poems that would flow naturally through the seasons with these earlier verses.

Readers of our blog have commented how the scenery and words relax or move them. They love how Eivor and Pearl look at the world, how their adventures make them smile.

The majority of these poems are haiku, haibun or tanka. Traditionally, these poems begin with quiet poetic observation and conclude with a moment of philosophical or spiritual insight. They are written in rhythm with the seasons and the fluctuations of the weather within those seasons.

The images complement the words and are neither too close nor too far, enabling us to expand our imagination and appreciate the richness of the poetry even more.

You are welcome to dip in and out of this collection, to join us on our walks through heather and grass, to walk with us on the beaches and throw a ball. You are welcome to open a page at random and use it for quiet observation and meditation. However you choose to read this book, we hope you'll enjoy the journey.

With love from Eivor, Pearl and Xenia xxx

THE POEMS

Skylark

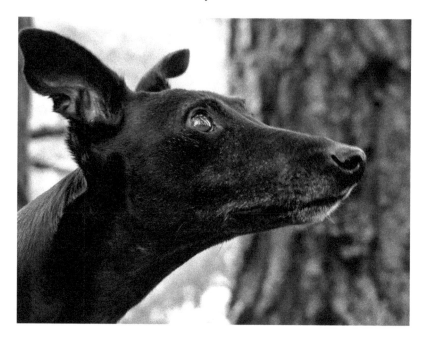

the air sleeps
through the trees a starry song
rises and rises

Spring Air

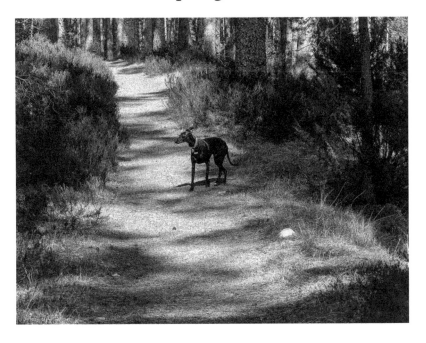

from afar this light
finds her way through the trees
over and over
we pause, silent,
breathing the spring air

Nature's Spirit

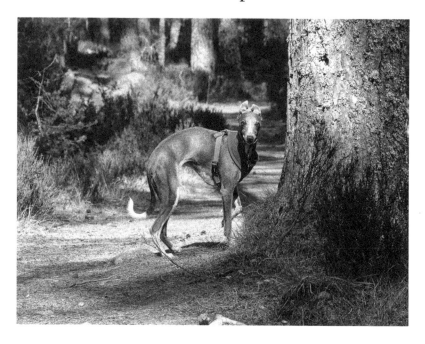

We're walking through the forest at Easter, the sun is bright and warm. It's the warmest Easter we've known since moving to the Highlands. Eivor walks beside us, touching my hand with his nose to let us know. To let us know how good it feels to be here.

Pearl walks slightly ahead, sniffing the bark of a pine, touching a twig or leaf. Prints from paw and foot interweave behind us. Our eyes follow the movements between the trees across the water, where pairs of geese go quietly.

nature's spirit
stars flicker through the temple
of this world

On the Shore

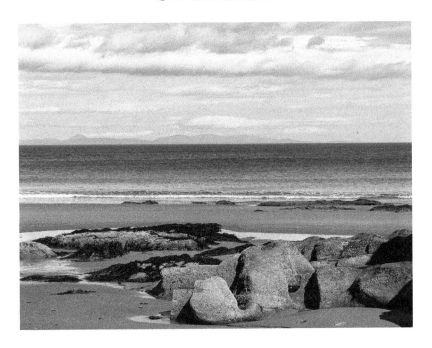

the tide sweeps out once more,
leaves seaweed resting in airs of spring

among the joys of shell and stone,
playful dogs and soaring gulls

it takes a while before the poem
plucks me from the mountains

Colours of the Sea

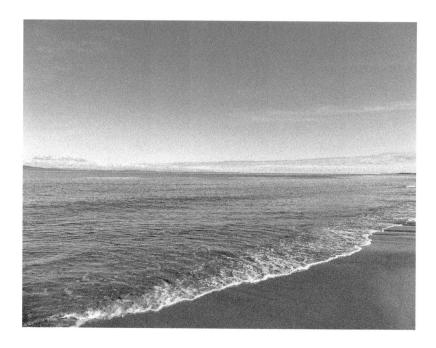

these colours
the new and ever newer
gifts from the sea

Sacred Forest

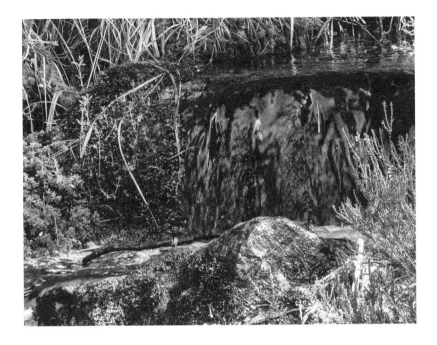

We take our time walking through the hills. Heather sleeps in muddy browns and mauves. Ground-nesting birds have made their homes. The scent of pine mingles with spring, a promise of tumbling green.

sacred forest
it looks a thousand years old
in flowing water

Allt na Bodachan

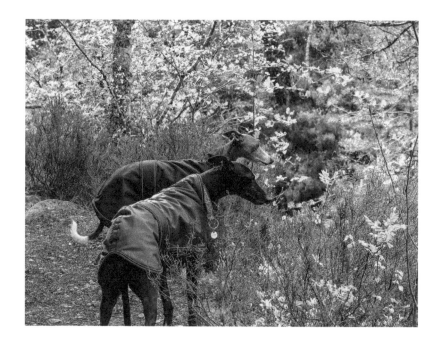

climbing the hill
the voice of the bubbling burn
a true companion

Spring Lanterns

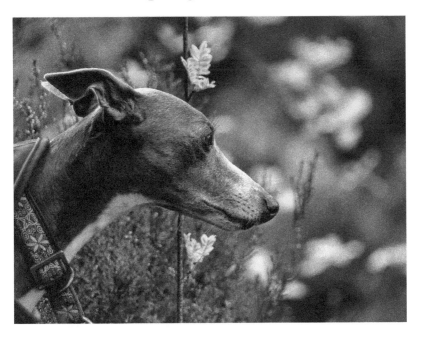

green waves
in the sun's warmth
spring lanterns

This World We Sail In (I)

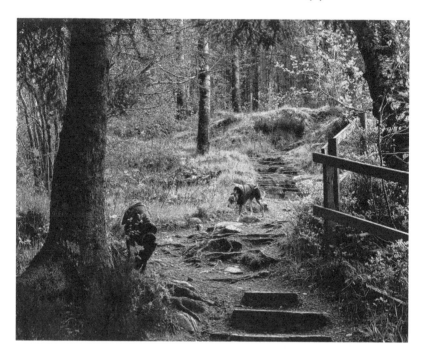

There are so many ways to climb the hill. Stone steps are here for those who stride big, who like something solid underfoot. I prefer to take smaller steps, feel the soil between my toes, the earth's heartbeat.

<div align="center">

may flowers
this forest speaks of growing
your own star

</div>

This World We Sail In (II)

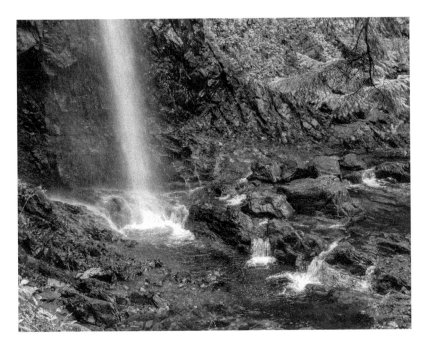

We pause to read messages left here by the deer, hear the swish of dippers' wings above the flowing water. It's here, in this silence, that we hear our guidance speak.

> this world we sail in
> the water on the outside
> spurs the dream

Passing Spring

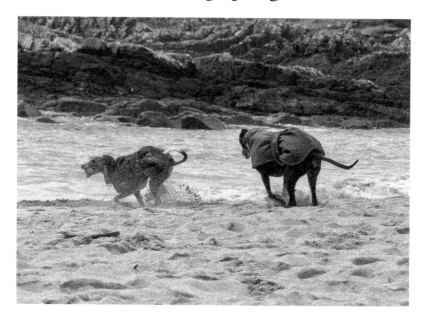

blossom haze
spring is passing
before our eyes

Hazy Morning

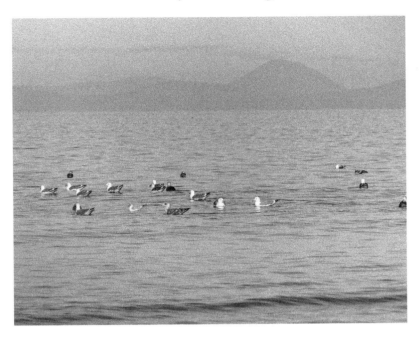

The air is warming again and the sandbar feels soft underneath. We walk here in quiet contemplation, leaving our footprints, until a line of surf cleans them away.

calm sea
a blue haze enfolds
our new horizon

Seagull

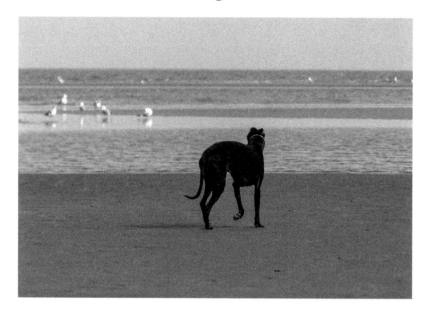

soul of the sea
the sweetest movement
between her wings

Song of Sika

The clear waters of Allt Mor tumble over the stones. The rains have been welcome since wildfires swept our moors. I love the smells of earth and water, the young green leaves. It's as if the forest can breathe again.

in the air
the soft whistle of sika deer
calling their young

Summer Solstice

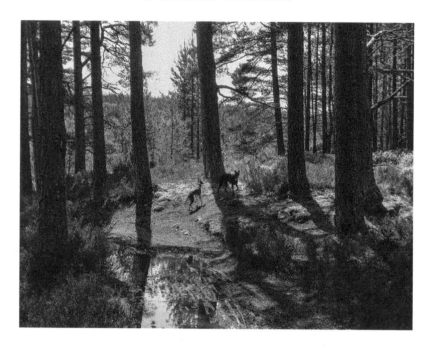

The forest is quiet as we leap and skip over dips with sleeping water. Trees and sky reflect in puddles across the path. I too reflect how far we've come. The long grass glitters in the light. Butterflies and hoverflies are dancing. After a week of wind and rain, it's good to be back in the warm.

summer solstice
one half of the journey
still to come

Radiance

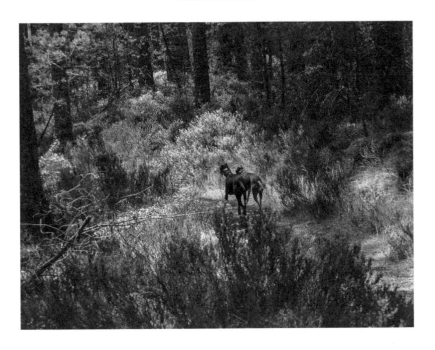

this stillness
in radiant light she gallops
summer's day

Bashō's Spirit

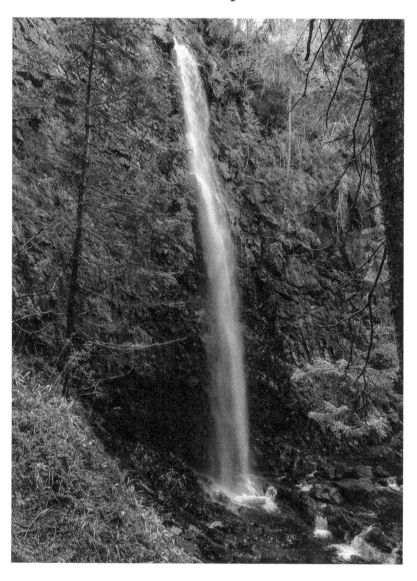

his spirit lives
in the mountains, waterfalls
far and near

Stretching Dreams

their eyes reveal
the sound of waterfalls
after the walk
dogs rest their noses
stretch out their dreams

Blue Ocean

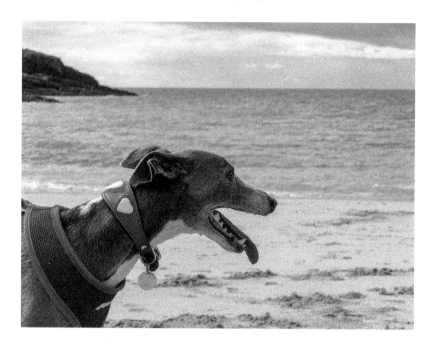

blue ocean
her eternity waiting
for our return

Plockton Bay

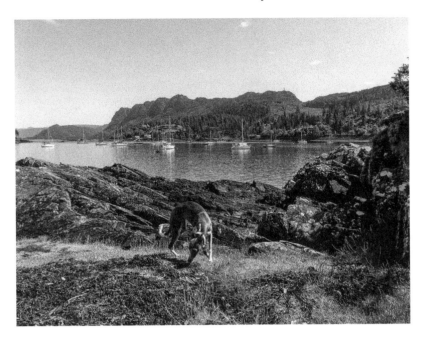

another sailor drops anchor
in the sheltered bay

mountains surround his sanctuary
with a calm he only feels

the wind blowing through his soul,
the waves rolling through his heart

A Message from the Stars
for our nephew, Jamie Baker (1977-1986)

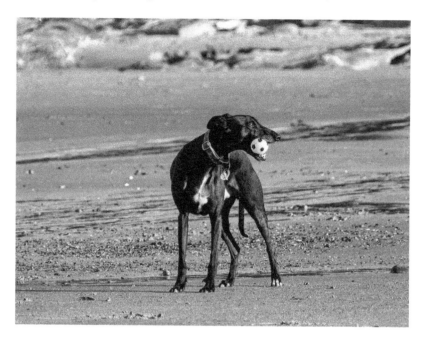

A small boy in an Everton shirt waves his arms like wings, shimmies down the dunes and kicks a ball across the tidal sands. A huge smile lights his face. He can move freely and breathes the fresh air. It's a different world from his hospital bed. Some of the players came to visit him, preparing him for what he'd always dreamt of. To walk onto the pitch as their mascot.

The day eventually came. The crowd roared. He and his twin sister stepped on to the grass. She carried the ball because he was too weak. She passed the ball to the referee. The team captains shook hands, put their arms around the children for a photograph. They wished the players good luck, waved at the crowd and watched their heroes beat Manchester United 3–1. It was an amazing day, one he would never forget. He fell asleep with a big smile on his face, taking the memories with him on his next journey.

<div style="text-align:center">

from the stars
you throw us a ball
a thousand smiles

</div>

When the Mist Rises

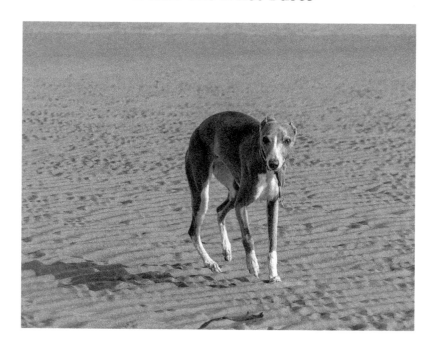

when the mist rises
this light that wraps around
where comfort falls
is always here for you
is always here for you

Heavenly Music

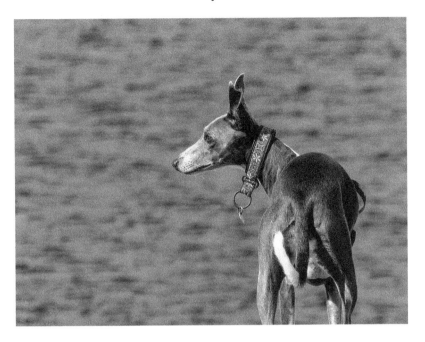

heavenly music
part of us remembers
the angel's harp

Memories

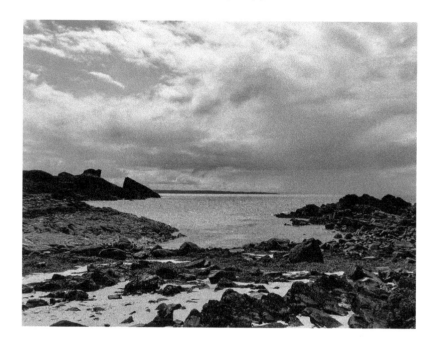

the flow
of black rock and turquoise waves
ocean's beauty
between us on the shore
the memories keep growing

Playing Ball

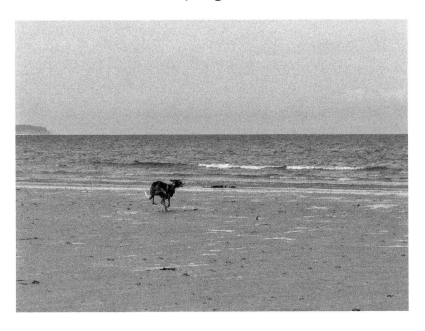

playing ball
a haiku spins above
the water

Origins

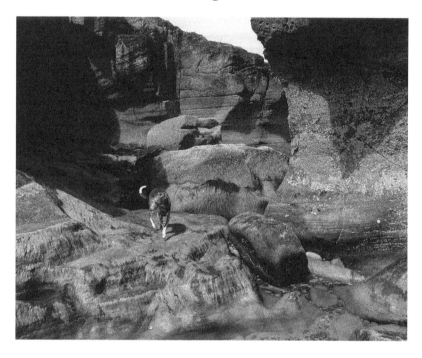

The stones are dripping with seaweed, marvellous and green between sand and silt, where the water has been. Clambering down these rocks, I wonder where their story began.

waves echo
through the open window
a plover's call

Stone Steps

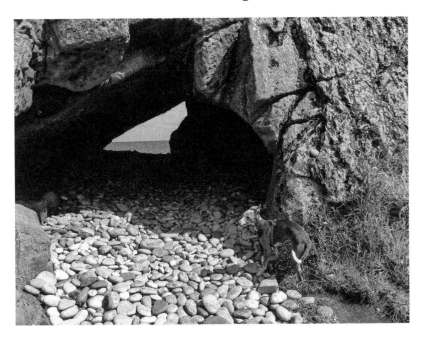

stone steps
so easy to trust
where they lead
when the moon floats by
to leave her blessings

Nature's Layers

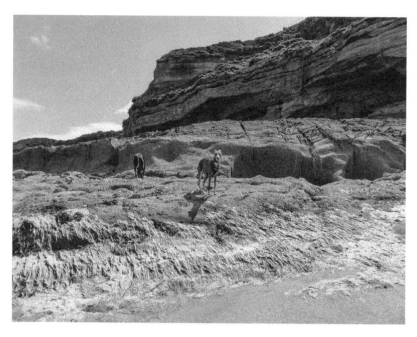

Layers of rock show us how much the climate here has changed. Permian sandstone tells us this area was once an arid desert.

With gorse and heather growing along the top, sea pinks flowering in the cracks and niches for nesting seabirds, part of this rock is now submerged at high tide. With one sniff and a good climb along the walls, Eivor and Pearl quickly make sense of it all.

<div style="text-align:center">

coves and caves
all that sings on the page
lotus flowers

</div>

Catching Footprints

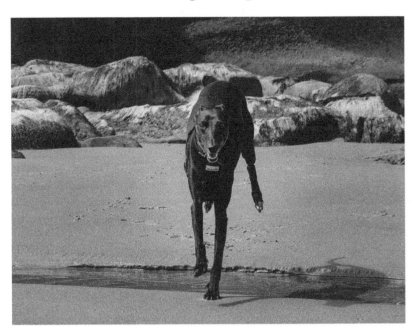

sheer joy
catching your footprints
in the air

Dawn to Dusk

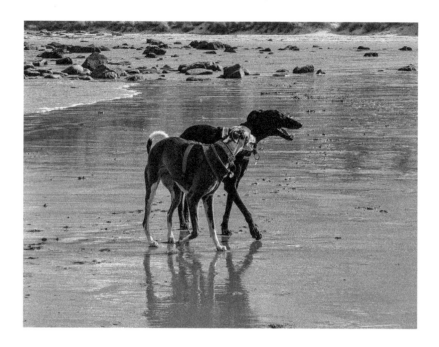

dawn to dusk
our love leads the way
into gentle seas

A Voice from the Unseen

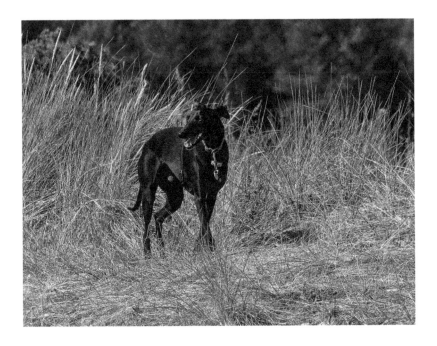

This place speaks of other times, long before the fishermen's cottages turned into holiday homes. It is still the same river that flows to sea past scattered stones, the sound of shingle. The people change, the houses change. The bay sleeps where it always has, between sheets of silt and honey-coloured grass.

ancient chant
an oystercatcher piping
above the waves

Deep Time

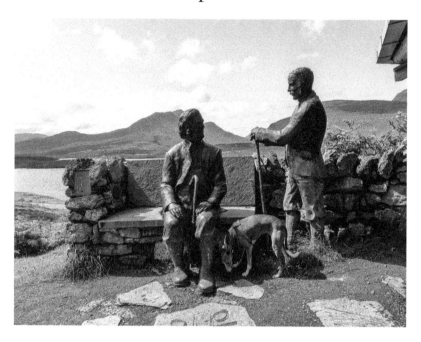

The grass roof of the Rock Room blends in with the ferns and heather of the hillside. Inside are display boards in English and Gaelic, explaining how parts of the earth's crust have travelled long distances. The older mylonites on display at Knockan Crag were forced upwards and over the later Cambrian layer.

There's a sculpture of two geologists, Ben Peach and John Horne, to celebrate these findings. Today the grass is growing around Horne's feet, some of the seeds tickle his knees. The sun feels extra warm after the morning's showers.

deep time
so many treasures
breathe the same air

A Special Encounter

A passing shower brings welcome freshness, more greenness to the grass. Water cascades from the top into a thousand tiny pools. We hear the *plop* of frogs. Careful where we place our feet, we continue to climb. Eivor and Pearl grind to a halt, star-struck. We know what they've seen. They ask whether we can see it too. We blink and tell them we believe them.

stag on the hill
greeting us in peace
a kindred spirit

Quiet Beauty

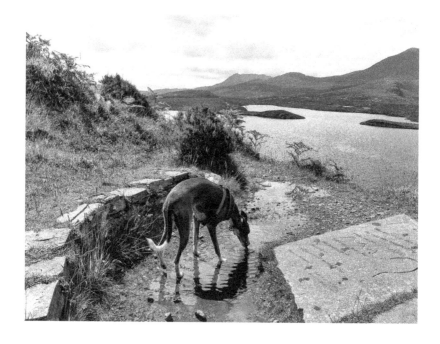

we drink the water
left here by the clouds
a white butterfly

A Wish

true kindness
between heather and grass
it glows and grows
end of treatment bells
for all the children

Lochs that Glitter

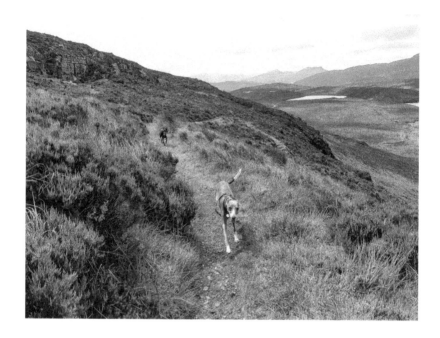

Loch Eadar dhà Bheinn winks at us from his mountain. Clar Loch Mor, Loch Dhonnachaidh and Clar Loch Beag make us wonder: have we met each other once before? If only we could stay, get to know them better. Their personalities, their taste in fish.

<div align="center">

crystal waters
the kindness in their names
a Gaelic song

</div>

A Field of Flowers

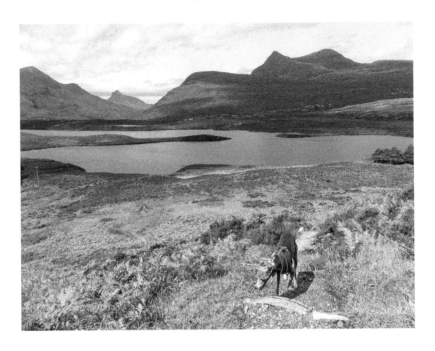

the stream flows
into a field of flowers
tonight's moon

Purple Splendour

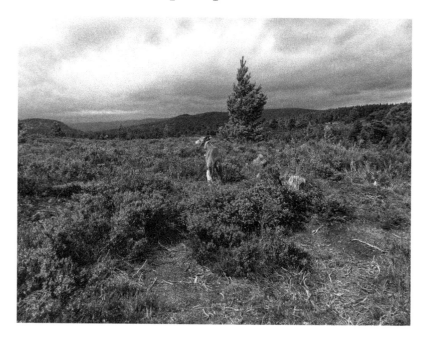

shining bright
the scent of heather
every flower
unique in this light
the way we all can be

Raven's Rock Gorge

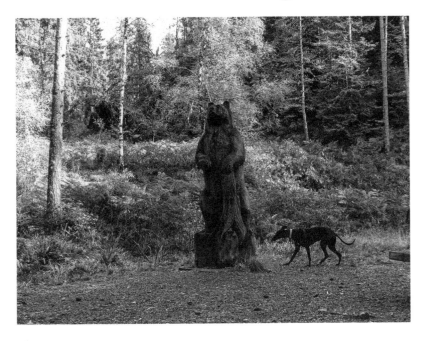

Shapeshifting waters flow down Allt Mor, offering glimpses of animals who roamed here before the leaves changed their colours. We sense the presence of spirits, the wise glint in the eye of the birds that gave their name to the rock above the path. Between beech and Douglas fir, moss climbs towards heaven.

light shimmers
ever-changing patterns
follow the stream

Autumn Gold

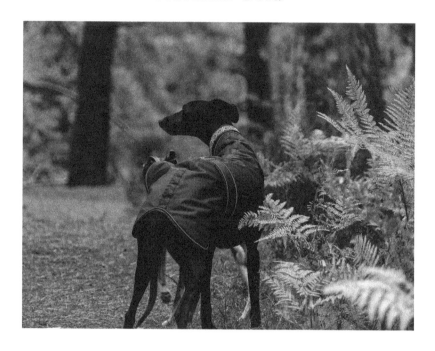

autumn gold
one fern after another
river's flow

In Every Leaf

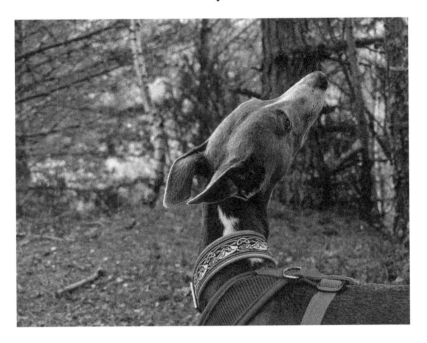

remembering
the light of the sun
in every leaf
the changing colours
of life itself

Morning Glory

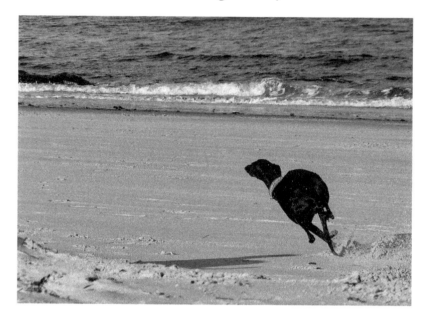

morning glory
how far can they run
autumn waves

Deep Inside This Hill

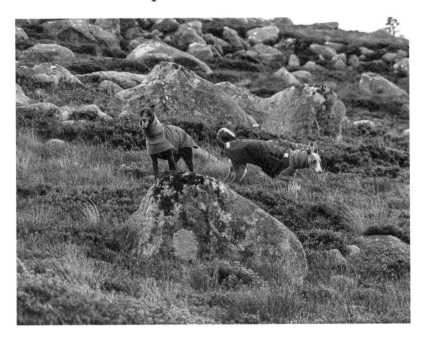

ah this love
between pine and stone
a heart beats
deep inside the hill
in rhythm with our own

Arch of Gold

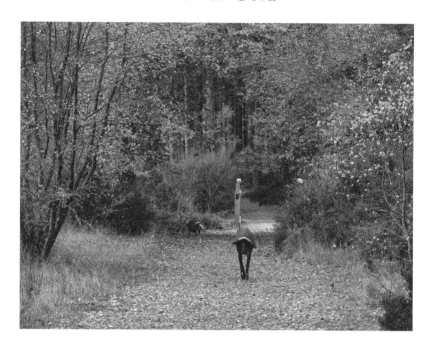

so many footprints
among falling leaves
the right way

Winter Mist

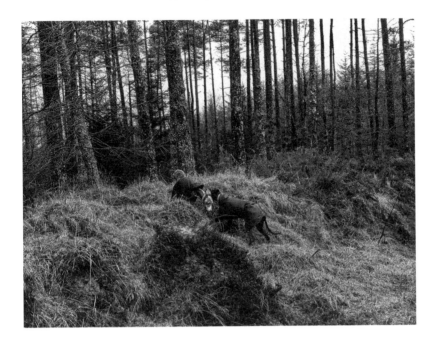

sharing a secret
between pine trees
winter mist

Two Ravens

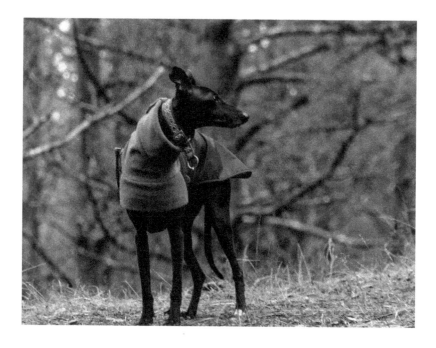

Our winter is still relatively mild. The roads are open, snow gates hooked to one side. This means we can travel. We can travel back to the forests we fell in love with in the summer. The forests that brought us coolness and shade now bring us shelter from the wind. We hear a slight movement in the trees, catch the glimmer in a knowing eye. Wrapped in mist between the trees, it feels like coming home again.

into the woods
with light on their wings
two ravens

Waiting for Snow

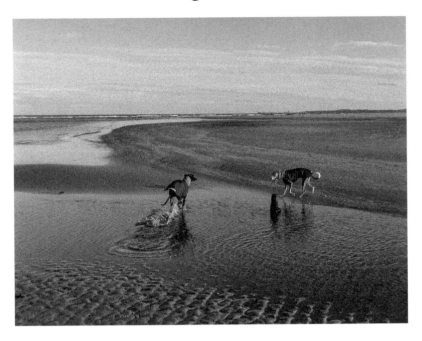

The weather changes daily. We celebrate the mildness when it rains, the sun's rays and clear blue sky on colder days. It's the kindest winter we've known since moving to the Highlands.

skipping the season
a pile of books waits
for snow to fall

Winter Dawn

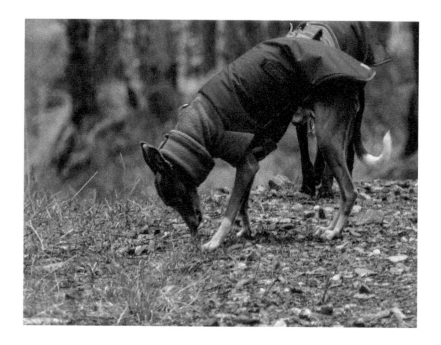

among the gold
fresh grass grows
winter dawn

Winter Comfort

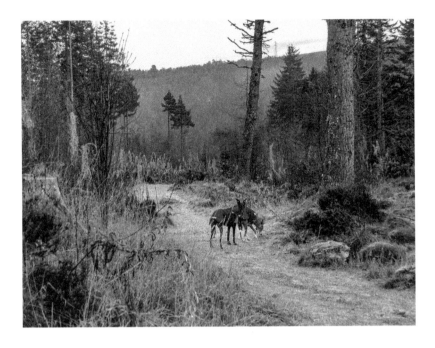

The air is crisp and cools as the sun slips behind the mountains. The faint smell of wood smoke mingles with pine and moss. It's time to leave the forest, before the light goes.

after the walk
grandma's bean soup
the first star

The Hawk's Eye

frozen puddles
winds flock in the sky
the hawk's eye
o to see so many worlds
weaving through the trees

Fresh Snow

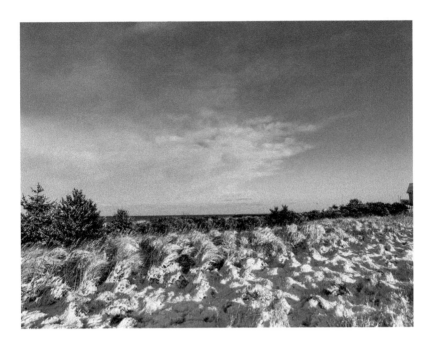

fresh snow
marram grass bows towards
the white blue sea

One More Glance

Gazing at all this beauty, before it melts away
the snow has been amazing, we wish that it could stay
we love it now with all our heart, while we run and play
to touch the stars that sparkle here, brightening our day.

A Dream Rests

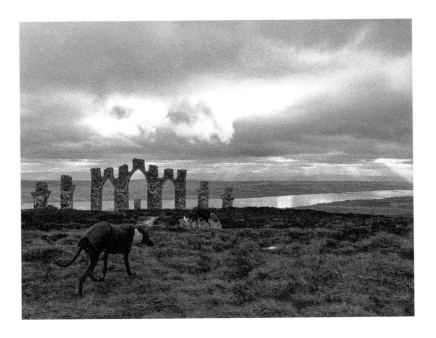

snow melts
on Cnoc Fhaoighris
a dream rests
between clouds and water
the path soothed by spirits

Silver Soft

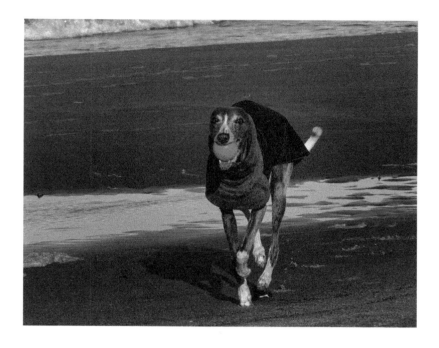

silver soft
a blue dog sends the moonlight
back to sea

Puddle Gazing

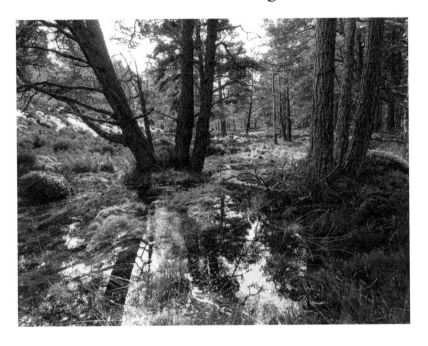

pine trees float
in puddles of snowmelt
the first green grass

Golden Hour

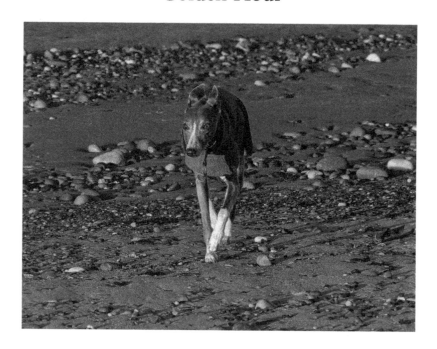

shingle
left here by the surf
one cosmos

The First Swallow

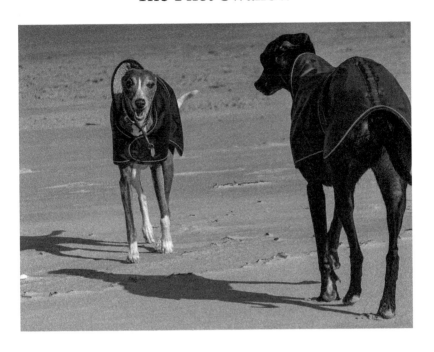

seeing
through rising and falling mist
the first swallow

A Safe Landing

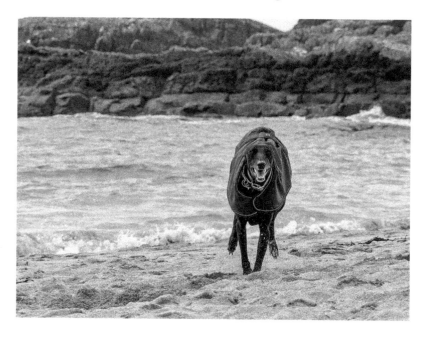

The journey from breeder to buyer, buyer to shelter and from shelter to forever home can be measured in hours and miles. The inner journey is often different, when the world you once knew is turned upside down.

Nature is a great healer. The subtle sound of the sea, the call of a gull, the deep silence in rock pools. Green seaweed glistening in the sun gives comforting smells, a new sense of home and belonging. Our roots grow deeper. Our love grows deeper still.

<p align="center">beaver moon
another leap forward
this journey</p>

Gratitude

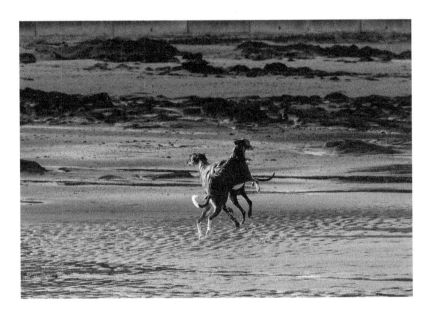

dancing
in a beam of sunlight
gratitude
for love, home and family
forever in our hearts

Divine Love

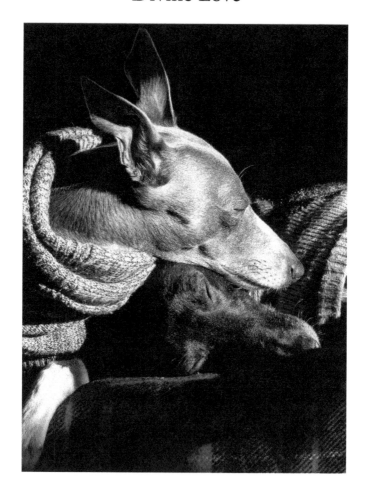

divine love
every memory
a lasting gift

ABOUT THE POETRY FORMS

Haiku

Haiku is a Japanese poetic form that evolved during the seventeenth century from previously existing Chinese and Japanese forms of Zen poetry. Matsuo Bashō (1644–1694) is one of the best-known haiku poets of that era and his work has been translated and interpreted by scholars around the world.

By its early practitioners, haiku was seen as a way of life. To write a haiku, or to read one, was a reminder of the impermanence of all that we experience on our journey. Haiku are usually written in the present tense, and seek to capture fleeting moments in the seasons of nature and the seasons of our lives. There is often a spontaneity, a wide-eyed way of looking at something that is captured with humility, using simple language.

Japanese haiku contain a seasonal word, or *kigo* – a word that indicates the time of year in which the haiku takes place. The traditional haiku is made up of seventeen sound units, known as *on*: five in the first line, seven in the second line and five in the third line.

As the popularity of haiku spread around the world, these sound units were equated to syllables, though in fact they are not the same. When Anglophone poets tried to limit their haiku to seventeen syllables in lines of 5-7-5, the result was usually stilted and a far cry from the swiftness and vitality of their Japanese lodestars. Today, this practice of syllable-counting is no longer promoted by the majority of contemporary haiku poets and organisations.

Bashō's haiku evolved over his lifetime, and the same is true of two of his famous successors, Yosa Buson (1716–1784) and Kobayashi Issa (1763–1828). For all three, the later work is quite different to the early writing. In this sense haiku is also about capturing change: each poem distils the essence of a moment, but over the course of a lifetime's work, the sum total of those moments reveals a story of personal growth.

Throughout the ages, the rules for composing haiku have been revised many times. One of the rules that is still adhered to by some of today's poets is that a haiku is divided in a fragment and a phrase. The fragment can either be the first or the third line. For example:

full of blossom
the song of a blackbird
echoes the wind

Here 'full of blossom' is the fragment and 'the song of a blackbird echoes the wind' is the phrase. But in the haiku below it is the other way around: 'chirping between tree buds' is the phrase and 'a blue sky' is the fragment.

chirping
between tree buds
a blue sky

Japanese writers use 'cutting words' (kireji), which in Western haiku are often translated as a punctuation mark, though they are not the same thing. Jane Reichhold, one of our leading haiku poets, has suggested that in English haiku, syntax can be used to express the necessary breaks without the need for punctuation.

Like the traditional haiku poets, I would describe haiku as a way of life, a way to look and marvel at nature and see the magical in the ordinary. To me, this is very much in the spirit of how Eivor and Pearl experience the world. Haiku gives us an opportunity to capture these moments in a few words so that others can catch a glimpse of what we see and connect it to their own experience.

Tanka

The tanka originated in Japan's imperial courts and was frequently written by women. It contains thirty-one sound units spread over five lines. As in haiku, the first seventeen sound units are spread over the first three lines, and many of the same rules apply. Whereas haiku are written in the present tense, tanka can switch between tenses and voices, using the third line as a pivot on which the poem shifts in mood or subject. The pivot line also allows the poem to switch between reality and fantasy, between memory and dream, or simply between one location and another.

Tanka were used as a form of correspondence between lovers and friends, and to mark significant occasions such as births and weddings. Poets also wrote tanka as a way to write with greater expressive emotion than haiku allowed.

Haibun

Like haiku, the haibun originated in seventeenth-century Japan, and was first developed by Bashō in his travel journal *Oku no Hosomichi* (Narrow Road to the Deep North).

A haibun consists of one or more paragraphs of prose, such as a passage from a letter or journal, followed by a haiku or tanka. The poem part of the haibun is used to bring a different voice or dimension to the piece and can be an effective way of telling two stories at once. A third dimension can be added to a haibun in the form of calligraphy or a photograph. Some poets refer to a haibun containing a tanka as 'tanka prose'.

The journey through the landscape recorded in a haibun can refer to the outer landscape of nature as well our inner personal landscape.

I give all my haiku, tanka and haibun a title for ease of reference, though traditionally they are untitled.

Sijo

Though older than the haiku, tanka and haibun, the Korean sijo shares a common ancestry. All evolved from ancient Chinese patterns. Traditionally, sijo were composed over six lines or three couplets. Since the twentieth century, the composition of the sijo has consisted of three lines of 14–16 syllables each, totalling between 44 and 46 syllables. A pause breaks each line approximately in the middle. The sijo may be narrative or thematic, introducing a situation or problem in the opening line, a development or 'turn' in the middle line, and a resolution in the final line. The first half of the final line employs a 'twist': a surprise of meaning, sound, tone or other quality. The sijo is often more lyrical, subjective and personal than the haiku, and the final line can take a profound, witty, humorous or proverbial turn. Like haiku, sijo has a strong basis in nature.

The poems 'On the Shore' and 'Plockton Bay' are the only sijo in this collection.

Ruba'i

A ruba'i is a classical Persian quatrain (a poem with four lines), sometimes written as two couplets, with a rhyme scheme of aaaa or aaba. The lines each contain thirteen syllables. Edward Fitzgerald popularised the form in English with his translation of the ruba'i of Omar Khayyam in the nineteenth century.

The poem 'One More Glance' is the only traditional ruba'i in this collection.

The summaries above are a brief introduction to the poetry forms used in this collection. If you are interested in finding out more, there are useful reference books in the Bibliography section of this book and there is a wealth of information available online.

At the time of writing, the Haiku Foundation provides archives, resources and regular haiku exercises and discussions for haiku poets from around the world at thehaikufoundation.org

For fellow Dutch haiku poets, Haiku Kring Nederland provides information on all things haiku and tanka with regular newsletters and a quarterly journal at haiku.nl

The resource library with information on haiku, haibun, tanka, sijo and other forms, created by the late Jane and Werner Reichhold for AHA Poetry, is currently still available at ahapoetry.com

ACKNOWLEDGEMENTS

'The First Swallow' has previously been published in *EarthRise Rolling Haiku Collaboration 2019* (Winchester, VA: The Haiku Foundation, 2019).

'Winter Mist' appeared as a featured Photo Haiku on NHK World's Japan Haiku Masters Series *Haiku Masters in Tokyo Part 1*, broadcast live from Tokyo on 4th March 2019, presented by Kit Pancoast Nagumara, Kazuko Nishimura and Dan Mitsu.

'A Dream Rests' has previously been published in the anthology *All My Years – A Tribute to Jane Reichhold*, edited by Chèvrefeuille (Lelystad, NL: Chèvrefeuille's Publications, 2017).

I am very grateful to Jim Kacian, Kit Pancoast Nagumara, Kazuko Nishimura, Dan Mitsu and Chèvrefeuille for featuring my work in this way.

This book owes much to many, including the team at Reedsy for their editorial support and Darlene Swanson for her creative visions for the cover and internal design.

A very big thank you to Kristjaan Panneman for his resources on Japanese poetry forms and regular haiku challenges at Carpe Diem Haiku Kai; the team serving poetry and virtual drinks at dVerse Poets Pub; Frank J. Tassone at his Haijin in Action Blog; Ronovan Hester at Ronovan Writes; Misky at The Twiglets; Frank Jansen at Dutch Goes the Photo; Cee Neuner at Cee's Photo Challenges; Amy, Ann-Christine, Patti and Tina at Lens-Artists; Paula Borkovic at Lost in Translation; Nancy Merrill at Nancy Merrill Photography; Terri Webster Schrandt at Sunday Stills; Becca Givens for hosting Nurturing Thursday; the team at the Rag Tag Community; and several others who provided regular prompts for linking images and words. I am deeply grateful to the followers of my blogs *Whippet Wisdom* and *Tranature* who take the time to visit and comment. Your input is much appreciated and your encouragement to publish more has been the guiding force behind this book.

A big thank you to all the teachers and fellow poets who have guided and inspired me along the writing path and the photographers who have encouraged me to stretch my camera skills that little bit further.

Words cannot express my thanks to Everton Football Club and their players for the hospital visits, their love and support and, above all, for making Jamie's dreams come true.

My heartfelt thanks to Brenda for her courage in this life and for suggesting Children with Cancer UK as a beneficiary of this book in memory of her twin brother Jamie.

Special thanks to the staff and volunteers at Children with Cancer UK for all the amazing work they do. It's an honour to support their work in memory of Jamie.

A massive thank you to the staff and volunteers in animal rescue and rehoming shelters around the world. We are grateful to be able to support you once again.

Last but not least, my everlasting thanks to Paul, Eivor and Pearl for their unconditional love and for being the best fellow adventurers through this life I could have ever wished for.

ABOUT THE AUTHOR

Xenia Tran was born in the Netherlands in 1962 and began writing and journaling at a young age. She enjoyed reading poetry in Dutch, French and English, and English soon became her language of choice for writing poetry and short stories.

Her early studies were interrupted by a desire to travel and explore different cultures. It wasn't until she was happily married and settled in London that she decided to return to study as a mature student.

She studied for degrees in French Studies and in Applied Linguistics at Birkbeck College, University of London, whilst working full-time as an administrator in a research centre and running her own holistic therapy practice.

In 2002 Xenia and her husband relocated to Kendal. There she joined a women's writing group, and her passion for creative writing was reignited.

She worked as a volunteer in a local animal shelter and later did voluntary work for a foster-based rescue organisation.

After attending a summer school at Queen's University Belfast she enrolled at Newcastle University, where she completed a postgraduate course in Creative Writing before relocating to the Scottish Highlands in 2010.

The beauty of the Highland landscape and the quality of its light inspired her to invest in a good camera and take photographs to accompany her writing for her blog *Whippet Wisdom*. The blog was a place to record the walks she and her husband took with their adopted dogs in images and words, and a stimulus for developing her writing and photography. It quickly gained a loyal following. She met and connected with poets, fiction writers and photographers around the world, and

in 2018 she started a second blog, *Tranature*, to share her personal observations on nature.

Her poems have appeared on television, in online poetry journals, print magazines and anthologies. Her first collection, *Sharing Our Horizon*, was published in September 2018.

ABOUT THE CHARITIES

Children With Cancer UK

This book has been specially created to support Children with Cancer UK, in memory of our nephew Jamie Baker. Although Jamie's dream came true when he walked onto the pitch as a mascot for Everton FC, he was never able to ring the end of treatment bell.

In Jamie's day, only a small proportion of cancer research focused on cancer in children. Children with Cancer UK is working to redress the balance. They invest heavily in research to develop better and kinder treatments for children. The charity funds temporary accommodation and works with its charity partners to provide grants to families struggling with the added financial pressure cancer diagnosis brings. They arrange fun days out so that families can enjoy themselves, share their experiences and remember that they're not alone.

It is Children with Cancer UK's mission to help every child ring their end of treatment bell, and to keep families together.

We are delighted to offer thirty per cent of net profits from the sale of this book to Children with Cancer UK and will announce our donations via our blog and Twitter (@WhippetHaiku).

If you want to find out more about the wonderful work this charity does you can visit their website at childrenwithcancer.org.uk, telephone 020 7404 0808 (09:00–17:30, Monday–Friday) or write to them at:

Children with Cancer UK
51 Great Ormond Street
London WC1N 3JQ

Registered Charity Number: 298405

Animal Rescue and Rehoming Charities

As with our first book, *Sharing Our Horizon*, we are delighted to share thirty per cent of net profits with animal rescue and rehoming centres at the end of each financial year.

The charities we donate to will be announced on our blog at www. whippetwisdom.com and via our Twitter feed @WhippetHaiku.

BY THE SAME AUTHOR

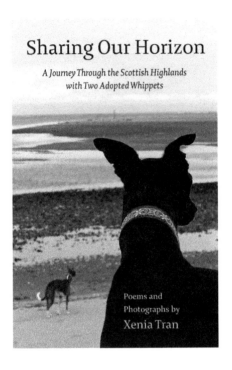

Sharing Our Horizon is Xenia Tran's debut collection of poems and photographs that capture moments in the Scottish Highlands with her two adopted whippets, Eivor and Pearl. Eivor and Pearl love spending time in nature, and the restorative energy of those quiet beaches, mountains and glens plays a big part in their rehabilitation. The poems are written in rhythm with the seasons and offer moments of philosophical or spiritual insight. Readers have described it as 'the perfect book to dip into and appreciate anew each time.'

Sixty per cent of net profits from the sale of *Sharing Our Horizon* go to animal rehoming charities.

The book is available in Paperback, Ebook and Kindle editions.

BIBLIOGRAPHY

Aitken, R, *A Zen Wave – Bashō's Haiku & Zen* (New York: Weatherhill Inc, 1995).

Aitken, R, *The River of Heaven – The Haiku of Bashō, Buson, Issa and Shiki* (Berkeley CA: Counterpoint Press, 2011).

Barks, C (trans), Rumi – *The Big Red Book, The Great Masterpiece Celebrating Mythical Love & Friendship – Odes and Quatrains from the Shams* (New York: Harper Collins Publishers, 2011).

Boa Nyx, I, *Small Clouds – In Memory of Jane Reichhold 1937–2016* (astrologyreboot.com: 2016).

Bowers, F, *The Classic Tradition of Haiku – an Anthology* (Mineola NY: Dover Publications Inc, 1996).

Brickley, C, *Earthshine* (Ormskirk: Snapshot Press, 2017).

Carson, C, *Belfast Confetti,* (Oldcastle Co Meath: The Gallery Press, 1989).

Donegan, P, Ishibashi, Y, *Chiyo-ni – Woman Haiku Master* (Singapore: Charles E Tuttle Publishing, 1998).

Hamill, S (trans), *Matsuo Bashō – Narrow Road to the Interior and Other Writings* (Boston MA: Shambhala Publications Inc, 1998).

Hamill, S (trans), *The Spring of My Life – Kobayashi Issa* (Boston MA: Shambhala Publications Inc, 1997).

Higginson, W J, Harter, P, *The Haiku Handbook – How to Write, Teach and Appreciate Haiku* (New York: Kodansha USA, Inc, 2013).

Klinge, G, *Day into Night – A Haiku Journey* (Rutland VT: Charles E Tuttle Co Inc, 1980).

Landis Barnhill, D (trans), *Bashō's Haiku* (Albany NY: State University of New York Press, 2004).

Landis Barnhill, D (trans), *Bashō's Journey – The Literary Prose of Matsuo Bashō* (Albany NY: State University of New York Press, 2005).

Lanoue, D G (trans), *Issa – Cup of Tea Poems, Selected Haiku of Kobayashi Issa* (Berkeley CA: Asian Humanities Press, 1991).

Lanoue, D G (trans), *Issa's Best: A Translator's Selection of Master Haiku by Kobayashi Issa* (New Orleans LA: HaikuGuy.com, 2012).

Lanoue, D G, *Pure Land Haiku: The Art of Priest Issa* (New Orleans LA: HaikuGuy.com, 2013).

Oliver, M, *Rules of the Dance – A Handbook for Writing and Reading Metrical Verse* (Boston: Houghton Mifflin Company, A Mariner Original, 1998).

Oliver, M, *Upstream – Selected Essays* (New York: Penguin Press, 2016).

Oliver, M, *Winter Hours – Prose, Prose Poems and Poems* (Boston: Houghton Mifflin Company, A Mariner Book, 2000).

Reichhold, J, *A Gift of Tanka* (Gualala CA: AHA Books, 1990).

Reichhold, J, *Writing and Enjoying Haiku* (New York: Kodansha USA Inc, 2002).

Reichhold, J (trans), *Bashō – The Complete Haiku* (New York: Kodansha USA Inc, 2008).

Reichhold, J, *A Dictionary of Haiku* (Gualala CA: AHA Books, 2013).

Rutt, R, *The Bamboo Grove – An Introduction to Sijo* (Ann Arbor: University of Michigan Press, 2001).

Stevens, J (trans), *One Robe, One Bowl – The Zen Poetry of Ryokan* (Boston MA: Weatherhill, 2005).

Ueda, M, *Bashō and his Interpreters* (Stanford, CA: Stanford University Press, 1992).

Van den Heuvel, C (ed), *The Haiku Anthology* (New York: W W Norton & Company Inc, 2000).

Wakan, N, *Haiku – One Breath Poetry* (Torrance CA: Heian International Inc, 1993).

Wakan, N B, *The Way of Tanka* (Brunswick, Maine: Shanti Arts LLC, 2017).

Yuasa, N (trans), *Bashō – The Narrow Road to the Deep North and other Travel Sketches* (London: Penguin Books Ltd, 1966).

STAY IN TOUCH

You can stay up to date with Eivor and Pearl's story by following our blog at:
www.whippetwisdom.com

and by following us on Twitter:
@WhippetHaiku

If you're interested in following our nature blog, you can also find us at:
www.tranature.com

and by following us on Twitter:
@tranature18

We look forward to seeing you there!

Lightning Source UK Ltd.
Milton Keynes UK
UKHW021010221119
354038UK00006B/174/P